WANKSY

Summersdale Publishers Ltd
46 West Street
Chichester
West Sussex
PO19 1RP
UK

www.summersdale.com

Printed and bound in China

ISBN: 978-1-84953-474-1

Substantial discounts on bulk quantities of Summersdale books are available to corporations, professional associations and other organisations. For details contact Nicky Douglas by telephone: +44 (0) 1243 756902, fax: +44 (0) 1243 786300 or email: nicky@summersdale.com.

WANKSY

INTERPRETING A GRAFFITI VIRTUOSO

summersdale

MARC BLAKEWILL
& JAMES HARRIS

ABOUT THE AUTHORS

As well as writing for TV shows such as *Horrible Histories* and *Russell Howard's Good News,* Marc Blakewill and James Harris also spend a lot of time walking past walls and hanging around in bus shelters. It is here that they first noticed the unheralded genius behind some of the iconic urban images of our times: the searing 'Dogs eat dirty pudding', the profound 'Emilly is a fat slag', the momentous 'Fucking snow', and so on.

In this book they have collected Wanksy's most significant work to date to ensure it is brought to the wider graffiti-loving public. Like Wanksy himself, they are truly doing their community service.

www.blakewillandharris.com

CONTENTS

INTRODUCTION

We live in a world where everything is designed. Smooth, clean lines are the bedrock of modernity. Simplicity, elegance and style are the graffiti artist's watchwords. Ergonomics is key. Freedom is faked. So isn't it nice, once in a while, to stumble across something genuinely off-the-cuff; a momentary thought encapsulated in a phrase, a sentence, a slogan or a drawing. An idea fossil, frozen in time.

And isn't it funny when people swear and draw cocks?

Pointless and puerile graffiti is a true art form – one that is shamefully underappreciated by the establishment – and there is no better exponent than the shadowy, subversive figure of Wanksy.

But who is Wanksy?

Some commentators think Wanksy is not one person, but several, all part of the same artistic tradition. But it is difficult to believe that a group of people could create such singularity of vision, depth of passion, intensity of purpose and still be able to run away.

After studying his works for several years, we are certain it is one individual who is responsible.

But why, people often ask, do you assume Wanksy is a man? We could tell you that it's something to do with the aggressive brush strokes, the masculine use of colour or the boyish charm inherent in the satire. But, ultimately, it's because girls have got better stuff to do.

Some say Wanksy is a renegade professor of art with a PhD. Others say he is a 15-year-old with ADHD. In a sense, his precise identity does not matter. If we were to say to you his name was Bill Stevens, a mobile phone salesman from Slough, would that change how you viewed the work? Or Tom Costello, a monobrowed plasterer from Rotherham? No. The art transcends the artist. And anyway, we've spoken to them and they can't even draw a proper cock and balls. There's no way it's either of them. But somewhere out there now is the true master – his brain teeming with ideas, his hand guided by the gods, his spray can held aloft like the torch of liberty.

In an age of fallen idols, we need a hero. That hero is Wanksy: the master of the mall; the genius of the ghetto; the da Vinci of da street.

Marc Blakewill & James Harris, London, 2013

VISION EXPRESSIONISM

VISION EXPRESSIONISM (n): Art that makes you want to get your eyes tested. Works often include incompletion and

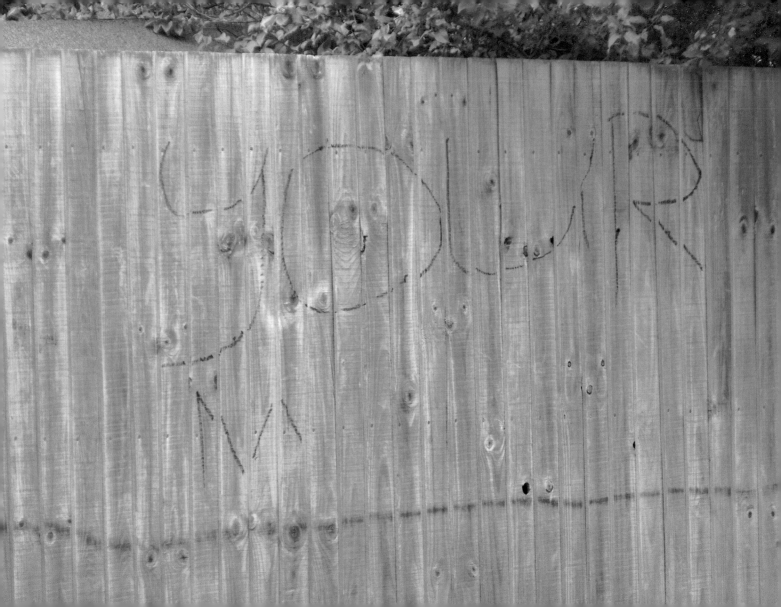

The incomplete phrase teases you. In an act of subconscious co-authorship you, the viewer, cannot help but complete the word.

Of course, the obvious choice is 'Your mum'. A timeless classic. But could it not also be a noun of virtue and grandeur? 'Your majesty' or, perhaps, 'Your magnificence'? What is it that makes these phrases less likely than something a snot-encrusted child might scream at you from the top deck of a bus? Is it probability or just prejudice?

It is, therefore, not the artist who determines the meaning of this work but our linguistic and cultural assumptions. This is one fence that cannot be sat on.

INTANGIBLE INSULT – felt tip on someone's fence

Like the radio operator on the *Titanic* furiously tapping away the letters 'iceber...' or the ticket collector on the *Hindenburg* politely reminding passengers it's a non-smoking flight, here we imagine a brave soul warning people of impending danger. But the word EMERGENCY is never finished. It is left hanging there – as pointless as a one-armed juggler, as useless as calling 99. It is imbued with sadness.

And yet there is another side to this piece. Does the word need to be complete in order for it to work? After all, some of the greatest works in history were left unfinished: Mozart's *Requiem*; the *Sagrada Familia* in Barcelona; Windows Vista. Thus, it can be argued that this is Wanksy's homage to the magnificence of the missing, the profundity of the partial, the brilliance of the bitty, the incomparability of the incomplete. Or he ran out of paint.

black paint on footbridge – **MASTERPIE**

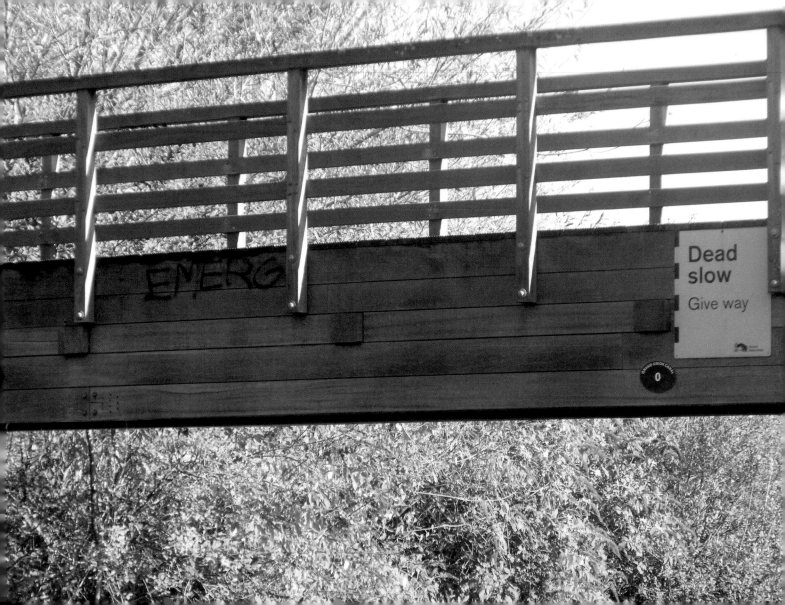

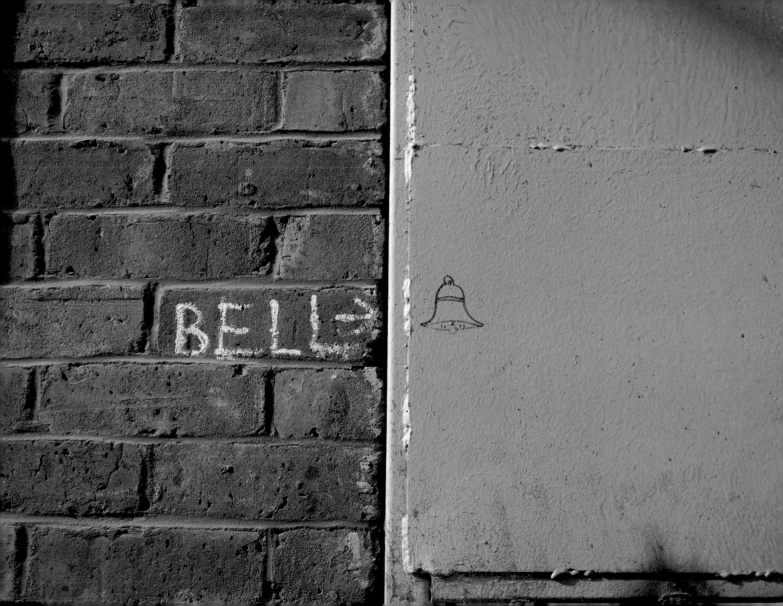

Nothing is real. Everything is a pretence. What we consider to be reality is just an image projected onto the screens of our retinas. It cost $63 million to make *The Matrix*, 'Nobel' cost 25 pence.

When you first view this piece, you think you understand it. Someone called Müdwig is a twop, and that is a bad thing. But Müdwig is not a real name, and twop is not an insult. What you have witnessed is a verbal illusion and you have fallen through the trapdoor of your own imagination. You twop.

MUDWIG IS A TWOP

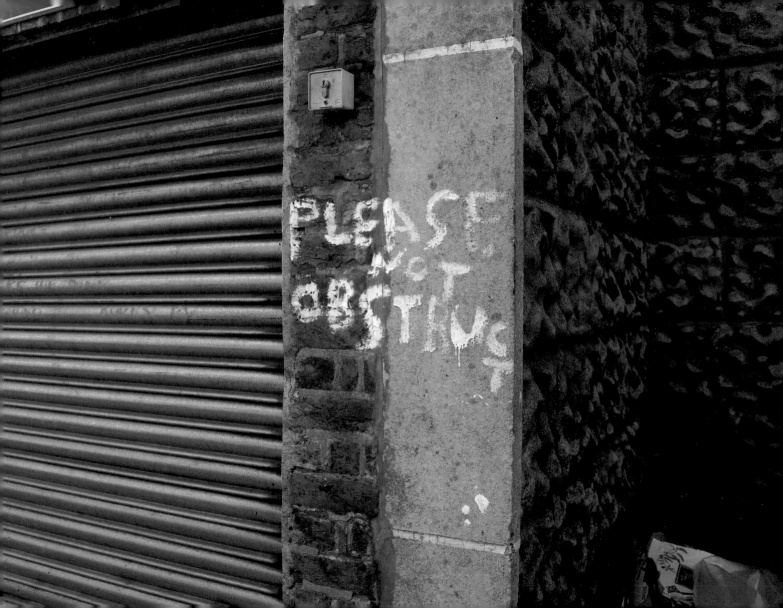

We think of obstructions as physical things – bollards, walls, nightclub bouncers. Here, the thing that blocks the completion of the phrase is thin air itself. Like the thin air in the head of anyone who would do this.

A brilliant critique of people who are less than brilliant at writing things on walls.

Wanksy's most famous work using transparent perspective.

Two men gaze out into the world and see themselves as the headline acts of their own lives: Paul and Rich. Meanwhile, the rest of the world looks in and thinks, 'Eh, what's that? Oh, those dickheads have forgotten to write backwards.' Clearly, we see ourselves differently from the way others do.

> ***Probably not inspired by the stained glass windows of the Notre Dame but decent nonetheless.***
>
> Monsieur Le Fevre, Notre Dame de Paris

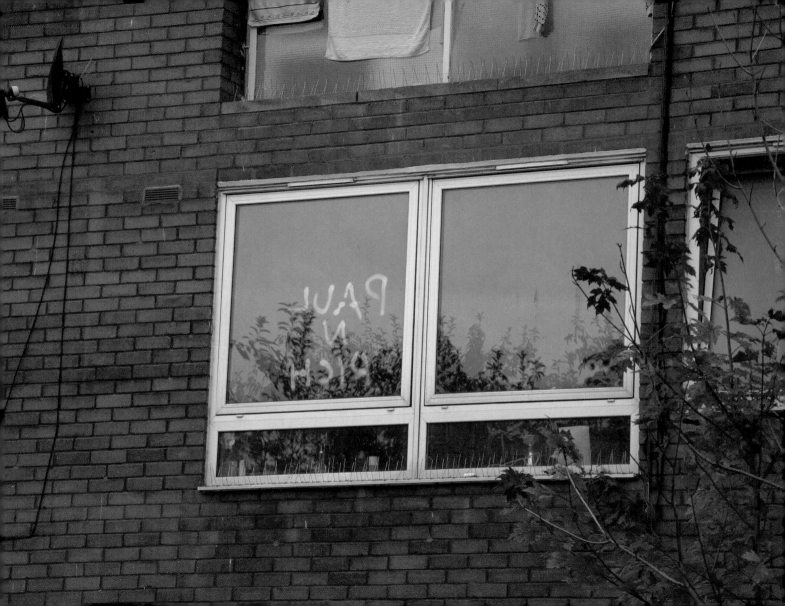

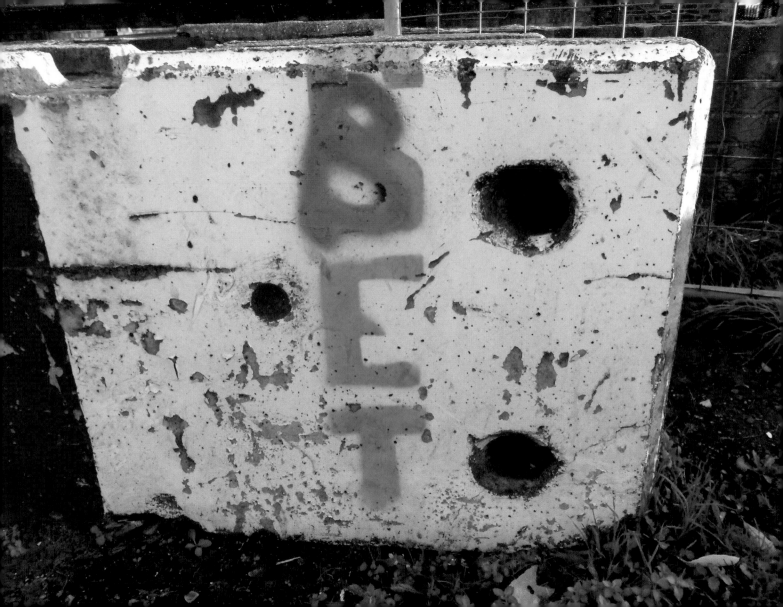

To change the word 'set' to 'bet' seems fairly innocuous, pointless even. But look at that big 'B', coloured pink like a neon light beckoning us to come hither and gamble our hard-earned cash.

It parodies a world where we are encouraged to bet on everything: from which football player will be the first to spit at the referee to the number of people who will commit suicide in a reindeer jumper on Christmas Day. Will this work be seen as a towering masterpiece? It's a racing certainty.

ON YOUR MARKS, GET SET... BET – red 'B' on concrete

Millwall; a white deer; a dangling, blue penis. As enigmatic as the quatrains of Nostradamus, as mystifying as hieroglyphics, one could gaze upon this in awe for hours.

“ *If that Dan Brown sees this, he'll write a new* Da Vinci Code *about it, you mark my words.* **”**

A local shopkeeper

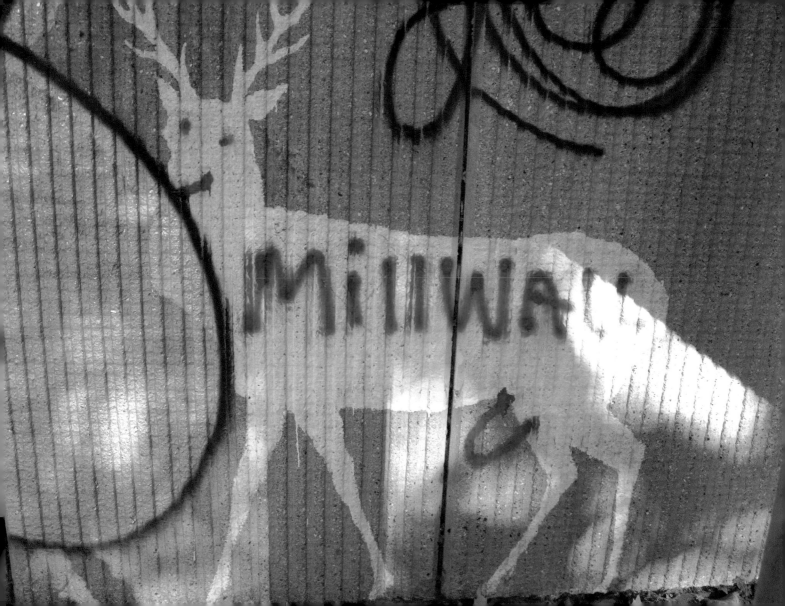

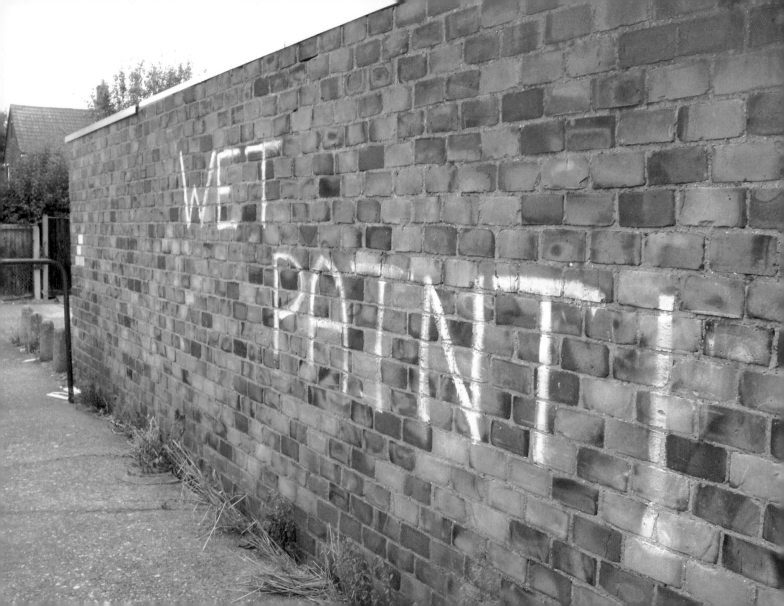

This moving and sad work tells us that no truth lasts forever. The paint that was once wet is now bone dry. Fact has evaporated and left a residue of fiction. 'Wet paint!'; 'England seem to be on top here'; 'Reality TV can't get any worse'. Sometimes the truth only lasts the for blink of an eye. Stunningly simple and simply stunning.

WET PAINT! – formerly wet paint on wall

Look at the scratchwork here. Notice the sloping text. This was no premeditated act. Wanksy etched this into the wall in a hurry, and that leads us to a startling conclusion: dogs were actually eating dirty pudding at that precise moment and Wanksy felt he had to warn the world about it. Such selflessness is all too rare. Thank you, Wanksy. Now we know.

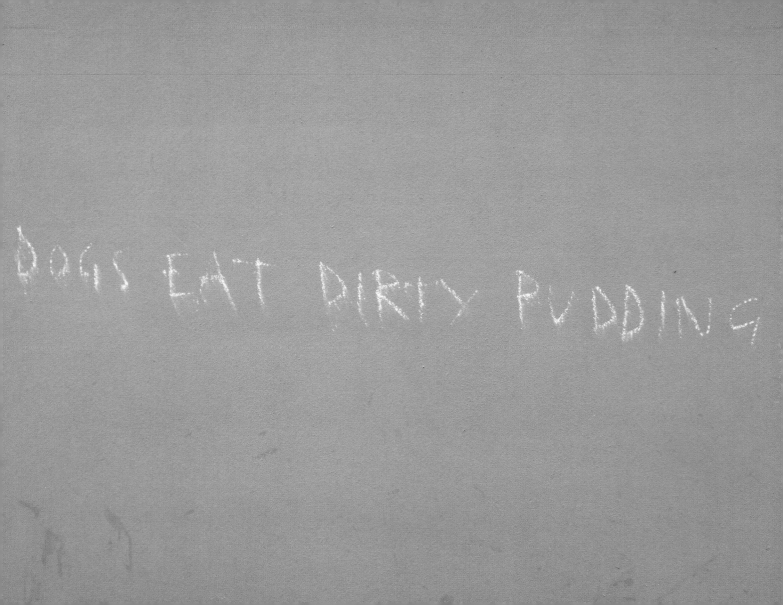

POSTMODERNISM

POSTMODERNISM (n): Modernism that is found on a post.

POSTPOSTMODERNISM (n): Modernism that used to be found on a post.

POSTPOSTPOSTMODERNISM (n): Modernism that used to be found on a post and is now on a different post.

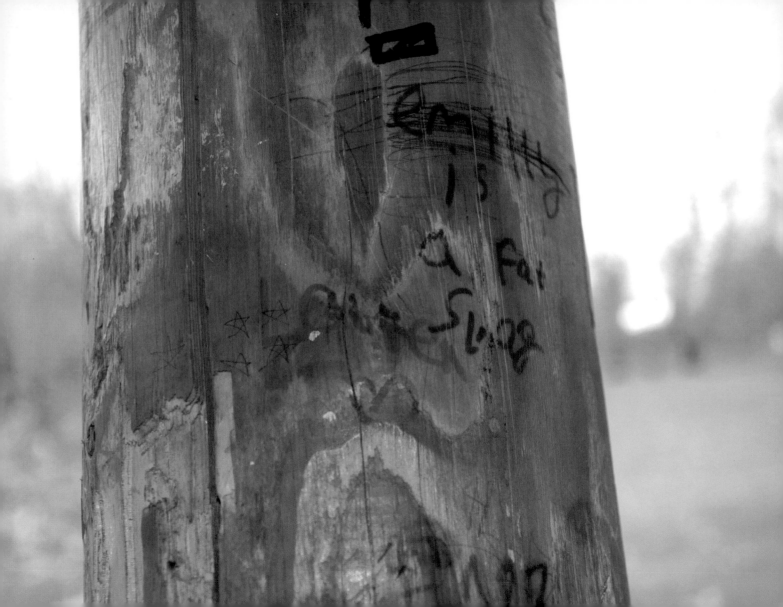

'A girl in today's Britain is more likely to get chlamydia than GCSE English.' This sort of remark can be heard at church groups and fondue parties up and down the country. But Wanksy knows better: today's younger generation don't just care about sex, texting, porn, kebabs, vajazzles, YouTube, sausage rolls and promiscuity. Their hearts beat with a love of literacy.

Confronted with a statement of shocking honesty about her weight and chastity, Emily chooses not to cross out the hurtful truth, but to correct the misspelling. Emily is a heroic guardian of the English language. Even if she is a fat slag.

EMILLY'S ENEMMY – aberration in red

This is a brilliant satire on gay conversion therapy. If someone thinks they can make you straight by attaching electrodes to your gonads or by telling you not to be such a bender, why can't a piece of graffiti on a post do the opposite?

I, the therapist, say: 'You are not gay.' I, the post in the playground, say: 'Listen, mate. You are well gay.' They are both equally preposterous. Inside this Trojan horse of a childish insult Wanksy has hidden an army ready to do battle against homophobia. Probably.

"*A blistering defence of twenty-first-century freedom of sexual orientation.***"**

Some gayer who read it

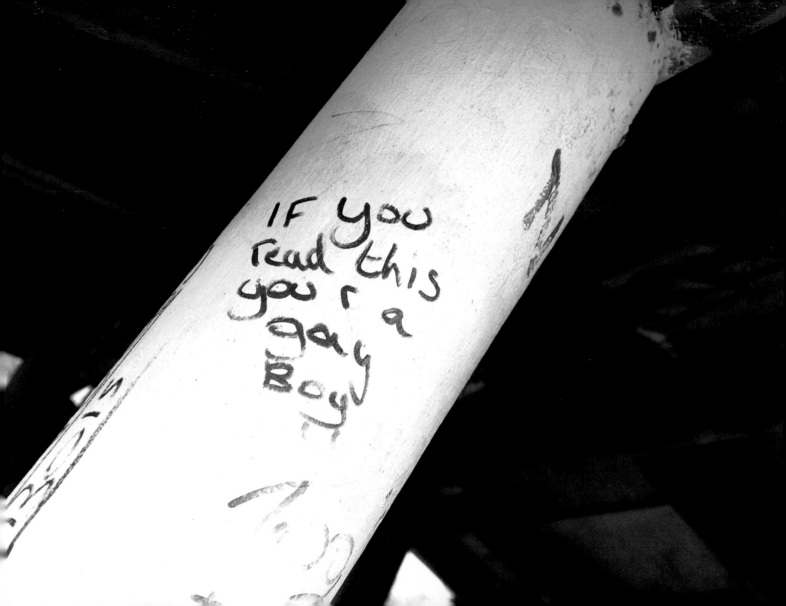

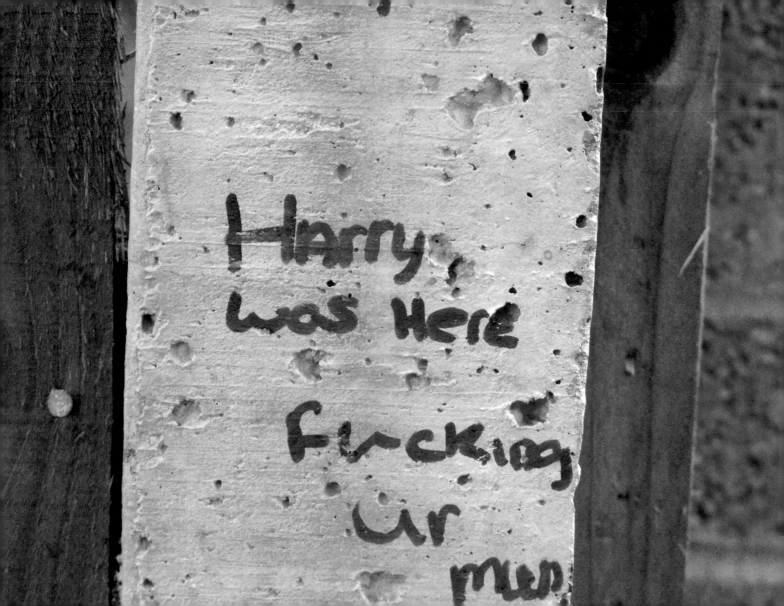

The work starts unpromisingly with 'Harry was here', a statement that one can find on bus stops everywhere. But then it mutates into something more powerful: Harry wasn't just there, he was doing something. He was fucking. But fucking whom, we wonder? Will the third line of the poem reveal the identity of the fuckee? No. It leads us on, through the darkest recesses of our deepest fears, to line five: the monosyllabic, monumental 'mum'.

Harry has been knobbing – my mum, your mum, all our mums. Rarely before in the history of art has this primal fear been better expressed in blank verse, in felt-tip pen on a concrete stanchion. Raw. Unflinching. Motherfucking.

They say drugs expand the mind. Unfortunately, they also expand the number of ways you can spell 'smoking'. What 'Just Say No' said in three words, 'Somking the weed' says in three words. Magnificently.

❝ *A work of gneius.* ❞

Austin Sawyer, MA

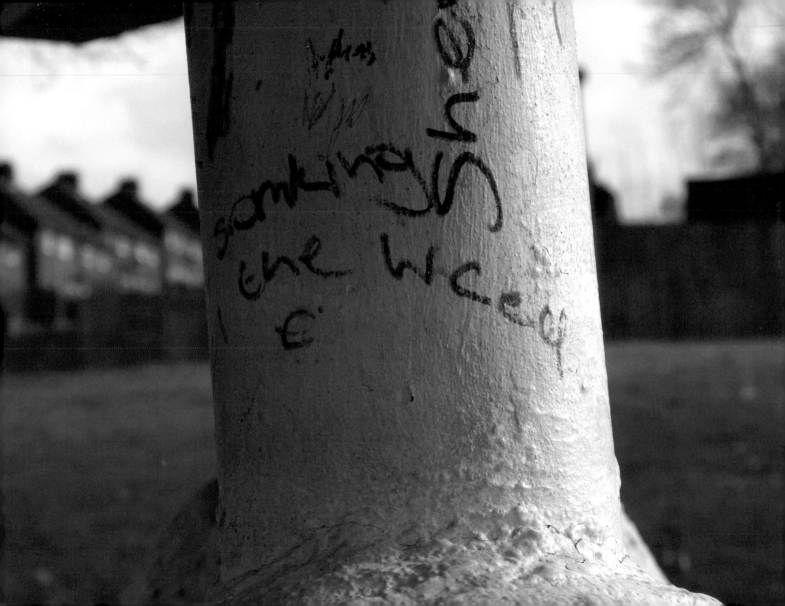

FINGERISM

FINGERISM (n): The act of using one's fingers to manipulate various materials such as fresh concrete or dirt on van doors. Also known as digitism and doing stuff with your fingers.

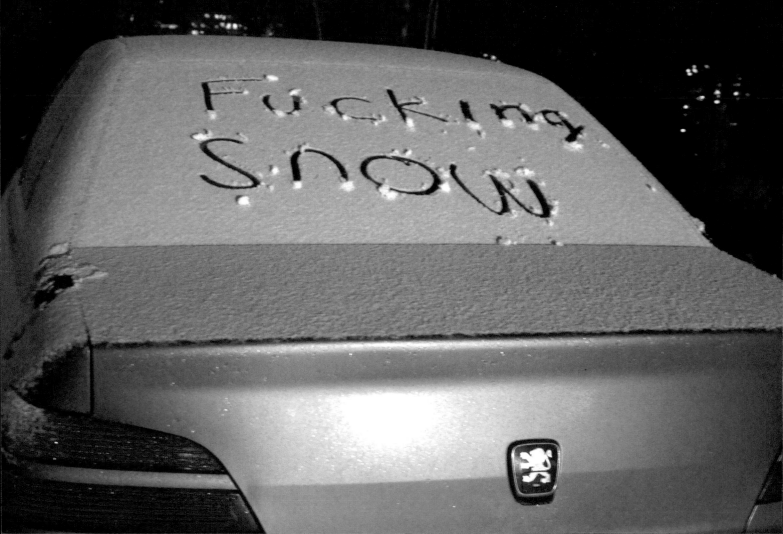

In this piece, the snow is the canvas, the materials and the subject itself. The message is the medium and the medium is the message. This is total art. Or it was until the driver turned on his rear heater.

❝ Fucking snow *is fucking brilliant.* ❞

Professor A. P. Nelstrop

❝ *I mean it WAS fucking brilliant.* ❞

Professor A. P. Nelstrop,

a day later

SNOW MOBILE – glove on window

This is a stunning homage to the history of art.

The subject matter takes us from the Neolithic – a caveman has drawn a penis on the back of someone's van – to the glory of the Late Renaissance. Just look at that perspective – the foreshortening of the shaft and the frozen momentum of the ejaculate as it journeys to the pavement.

Our eye is drawn to this lateral vanishing point as it reminds us that there is life beyond the canvas. What we are treated to here is a distillation of thousands of years of human achievement that 'clean me' can never hope to match.

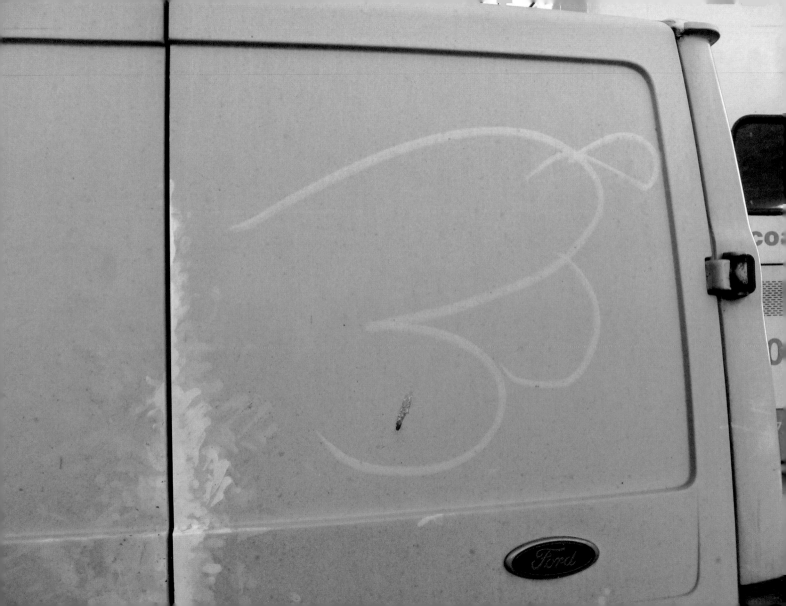

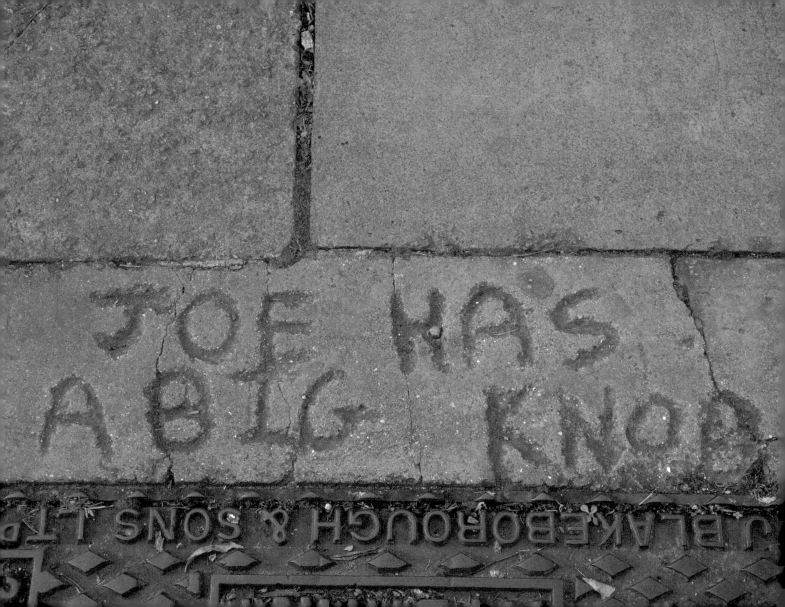

This is a complex and ambiguous piece. On first impression, it appears to be a simple boast by someone called Joe. 'I've got a big one!' Yet it is clearly more subtle and manipulative. How will men see these words? Only by stopping and looking past their own manhood. A smug Joe thus imagines men with their heads hanging downwards, contemplating the meagreness of their own members compared to his.

But who is this Joe? There is no surname. And so the final clue is revealed. He is none other than Joe Public. The message is uplifting: 'Worry not about the size of your plonker, for they are all big.' Brotherly, democratic, egalitarian, brilliant.

> **"A knob in Wanksy's hand is a magnificent thing."**
>
> Wanksy's girlfriend

Snowmen are usually made with eyes and a nose, but no genitals. This squeamishness about our bodies deeply offends Wanksy. And so he offers this glorious corrective: snow genitals, but with no snowman. A truly powerful piece made more impressive by the fact he did it in the dark with a car coming.

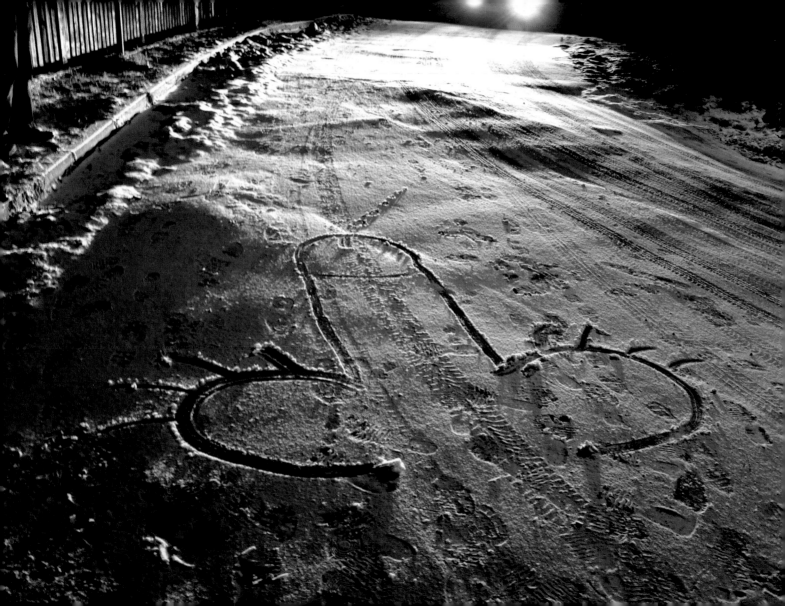

JISM (n): A shortened form of je t'aime-ism, Jism (or J-ism) is an art form that celebrates everything to do with love and sexual joy.

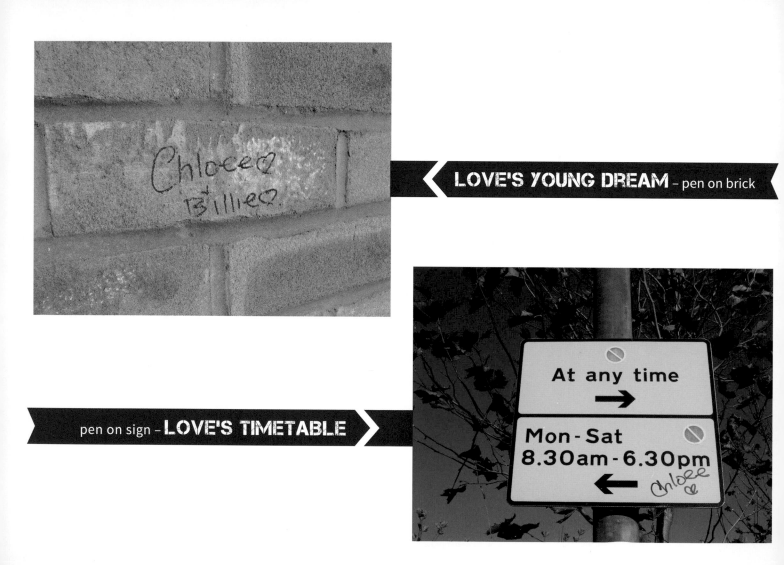

LOVE'S YOUNG DREAM – pen on brick

pen on sign – **LOVE'S TIMETABLE**

Chloee and Billie: a love story for our times. Not only have they scrawled a public commitment, but Chloee has vowed fidelity too.

'I, Chloee, take thee, Billie, to be my lawful wedded boyfriend. For richer, for poorer, for better, for worse, till 6.30 p.m. on a Saturday night when, fuck it, I'm anyone's.'

In a society where relationships are measured in minutes not years, this tale of commitment is touching. Chloee cannot manage total faithfulness, but she can promise not to get nailed by anyone else during working hours. How many women in modern-day Britain can honestly say that? Beautiful, moving, triumphant.

> **❝ By giving Chloee two 'e's, the artist hints at the female protagonist's easiness. But he turns this stereotype on its head by making Chloee the only one of the couple who promises not to sleep around for a large part of the week. An excellent example of modern feminist realism. ❞**
>
> Julie Bower, cleaner and part-time lecturer at Bournemouth Art College

The resplendent white of this proud phallus reminds one of a Neolithic fertility symbol carved in a chalk hillside. There is a reverence here; a primal impulse to worship the giver of life.

But this piece is not without its detractors. Firstly, there is the age-old issue of pubism: should a cock and balls be adorned with pubic hair or not? The purists say no, the pubists say yes. The pubists have gone as far as to say that they want this piece either follically amended or painted over. Strong words.

Secondly, there is the question of realism. Here, one testicle is clearly larger than the other. Some commentators are unhappy with this, claiming that this is a dangerous misrepresentation of reality. Others claim that these commentators need to take a good, long, hard look at themselves.

> **66** *If this were on a Dorset hillock,*
> *I'd pray to it.* **99**
>
> A local pagan

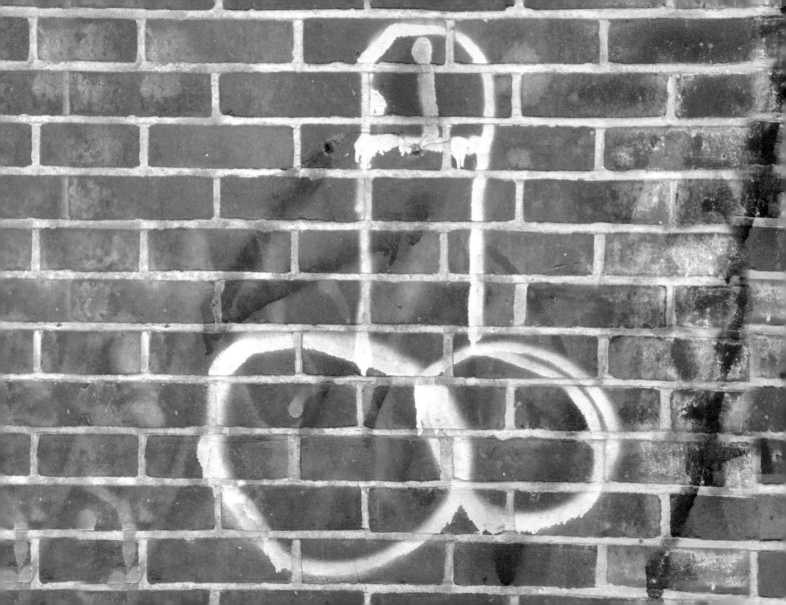

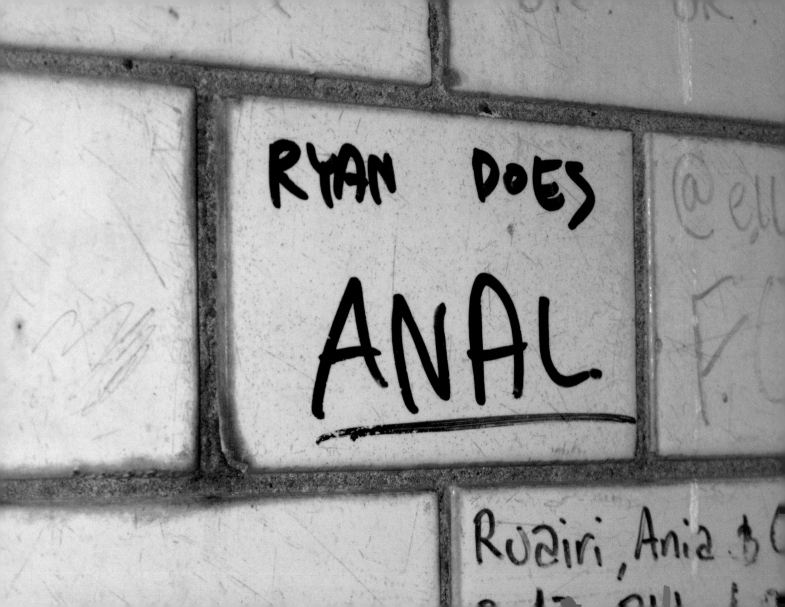

This could be seen as a tribute to the porn film *Debbie Does Dallas*, or the lesser-known *Ethel Does Scunthorpe*. This is to be mistaken. It is surely a commentary on how we have difficulty declaring devotion towards our lovers. Post-Freud and post-watershed, it seems easier to discuss the ins and outs of the bedroom than the sublime emotions of true love. And so it is here. Ryan is not talking about anal. Not really. He's talking about his paramour, Alan. Ryan loves Alan. He *does* Alan. But, like so many of us, he can only hide his romance behind a curtain of anagrammatical smut.

SHARING RYAN'S PRIVATES – confession on wall

One's love for another can be expressed in many ways. Shakespeare wrote sonnets, Shah Jahan built the Taj Mahal for his wife and Lee wrote 'Lee ♥ Kez' on the side of a rancid bin.

However, unlike the Taj Mahal, Lee's monument is on wheels and so his love for Kez can be proclaimed throughout the kingdom: in the street, in a stairwell, anywhere, in fact, a 500-cubic litre wheelie bin can go.

It might stink, it might be full of rotting food and used nappies… but it's love.

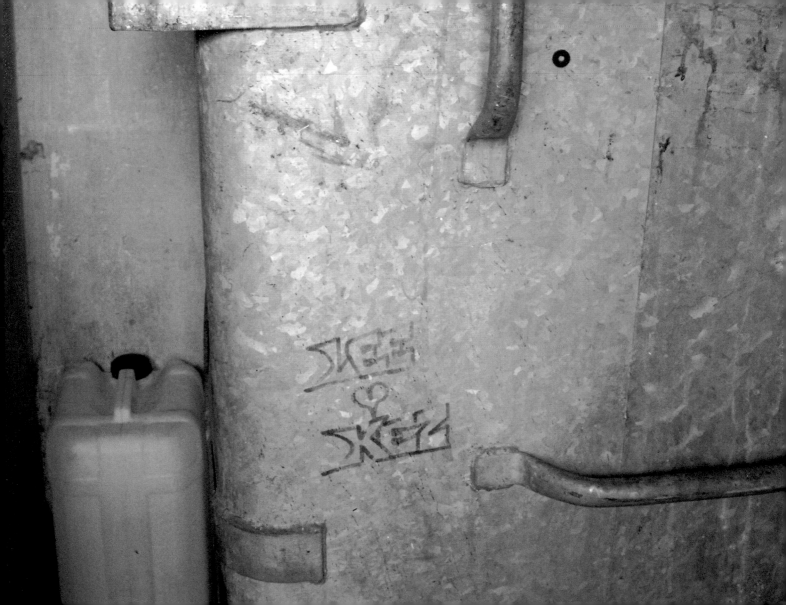

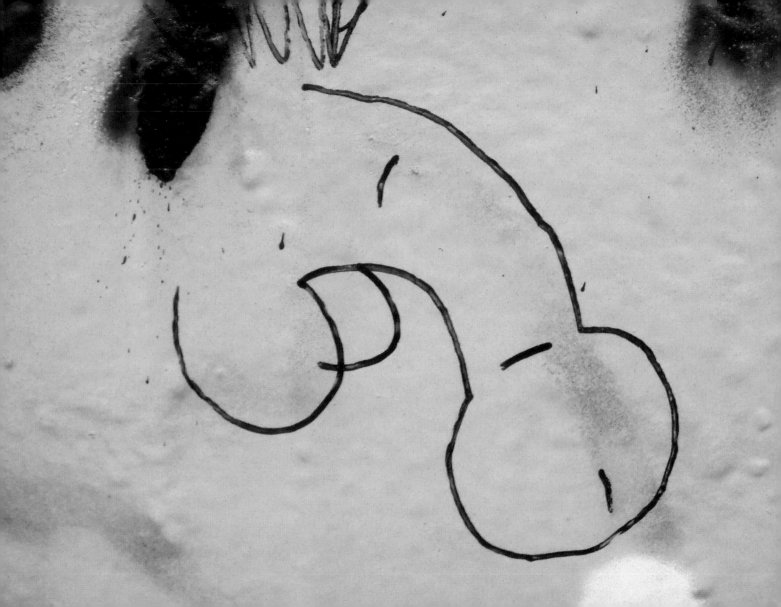

Many suggest that this is a self-portrait.

"It has all the hallmarks of a self-portrait. The casual, familiar lines; the honest disinterest of the phallus; the splodge of jizz. If this isn't Wanksy's knob, I'll eat my hat."

Director, Institute of Phallic Art

FIRST IMPRESSIONISM

FIRST IMPRESSIONISM (n): Art that begs a second look. Devices include misdirection, ambiguity and defacing street signs. Not to be confused with the work of the French Impressionists who were both French and Impressionists.

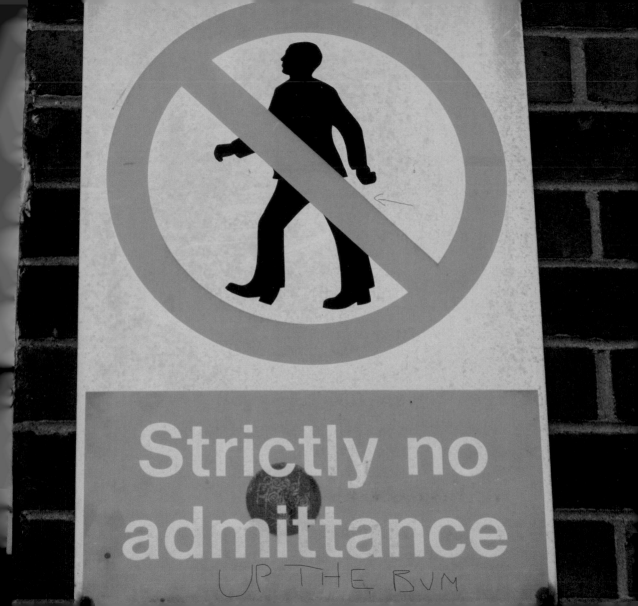

Strictly no
admittance
UP THE BUM

Look at this for a moment. Take your time. What do you see? Just a normal sign, right? Nope. A normal sign with 'Up the bum' scrawled on the bottom of it? Look again. Yes, there's the arrow pointing to the man's backside. But that's not it. That's not it at all. What do you really see?

You see an effeminate man being told he's not allowed into the building. Notice the Cuban heels. No straight man wears those. See the elegant cut of the man's suit; the jaunty twist of his wrist. Clearly, this sign is homophobic, and it takes a genius like Wanksy to undercut such outdated prejudice.

'I prefer smoking marijuana to sexual liaisons with young ladies.'

'I have just urinated over young ladies.'

Which came first to your mind? Really? Interesting...

With 'Weed over bitches', Wanksy has cleverly constructed an inkblot test – do you see a harmless butterfly or a fierce dragon? The choice is yours, dear reader. Pot head or pissing pervert. The choice is yours.

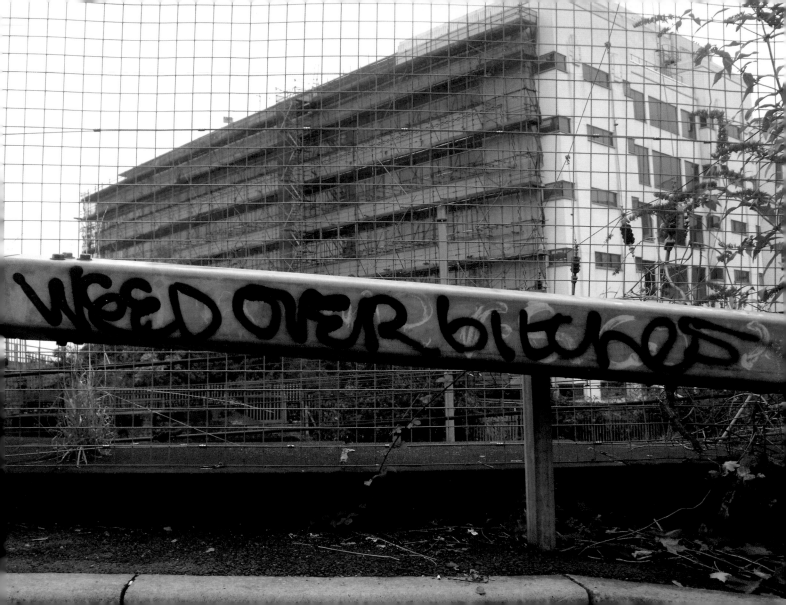

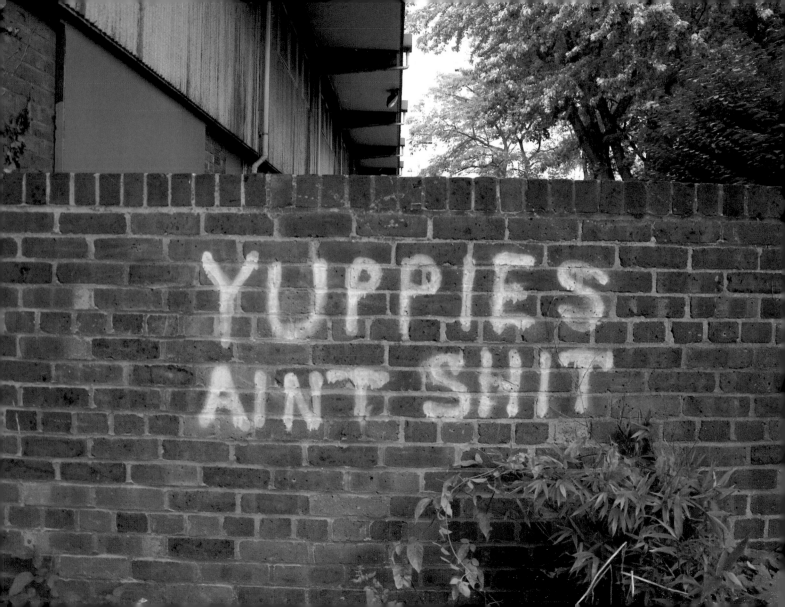

This appears to be a staunch defence of young, upwardly mobile professionals. But is it? In claiming they are not shit, we are left wondering why one might believe they were shit in the first place. And before we know it, a plethora of reasons come to mind.

Yuppies are people who fly Ryanair once a year to 'keep it real'; whose dinner parties have feedback forms; who see skiing as a life skill; whose children are learning Chinese but don't say thank you in English; who talk about 'equality of orgasm'; whose dogs have middle names; who count Pinot Grigio as one of their five a day; who think buy-to-let is a human right; who will drop you as a friend as soon as you fall out of their income bracket. And so we are left in no doubt: Yuppies are, indeed, totally shit.

❝ *The greatest counter-suggestible polemic in the history of counter-suggestible polemical art.* ❞

Head of Counter-suggestible Polemical Studies at Carlisle University

YUPPY LOVE? – council yellow on council wall

A proclamation in favour of gay marriage. Two cocks become one.

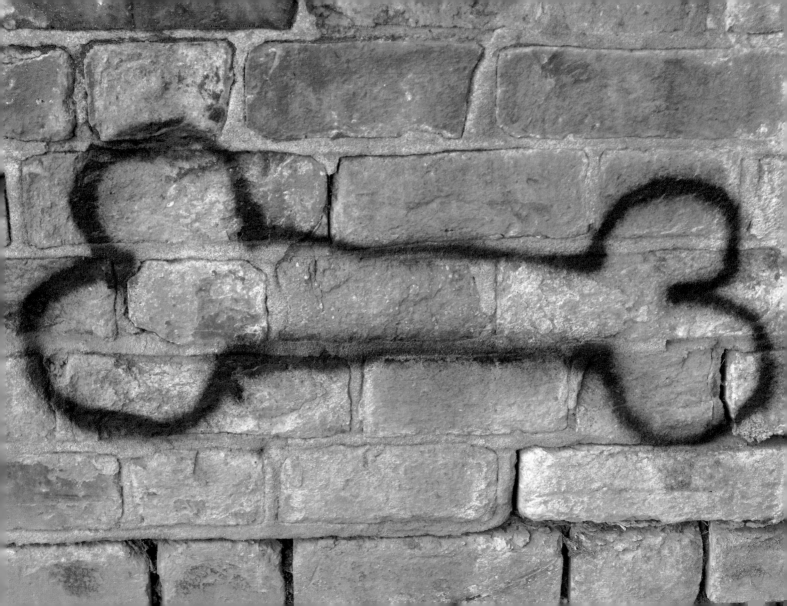

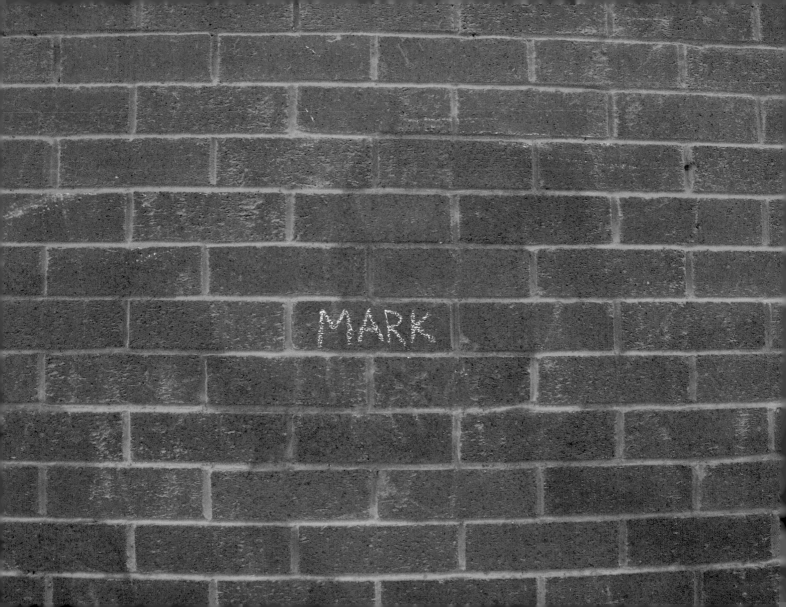

Graffiti artists often write their name to show authorship, to prove that they were 'here'. Whatever 'here' means in these post-9/11 times. In this instance, therefore, we might think Mark is the name of the author. But this is to misread it entirely: 'MARK' isn't a name, it's just what it says it is – a mark!

All art is but a mark upon the world. And that way sadness lies. For all its brilliance, this chalk on brick will slowly dissolve in the rain just as the *Mona Lisa* will fade, the Sphinx will crumble and One Direction will release a new album. Heartbreaking.

MAKE YOUR MARK – chalk on brick

What is art? Is it a Leonardo hanging in the Louvre? Is it a painstakingly sculpted piece of marble? Is it a question mark sprayed on the back of some bloke's lorry?

This question has never been asked until now.

Some experts have averred that this is the work of a mindless idiot. But not the owner of the lorry. He knows that he no longer drives a goods vehicle.

He is the curator of a mobile gallery. Every time he takes to the streets, the people behind will ask: 'Why on earth did someone bother to do that?' Which is exactly what is heard in the Tate Modern.

red spray paint on lorry – **TAILGATING THE TATE MODERN**

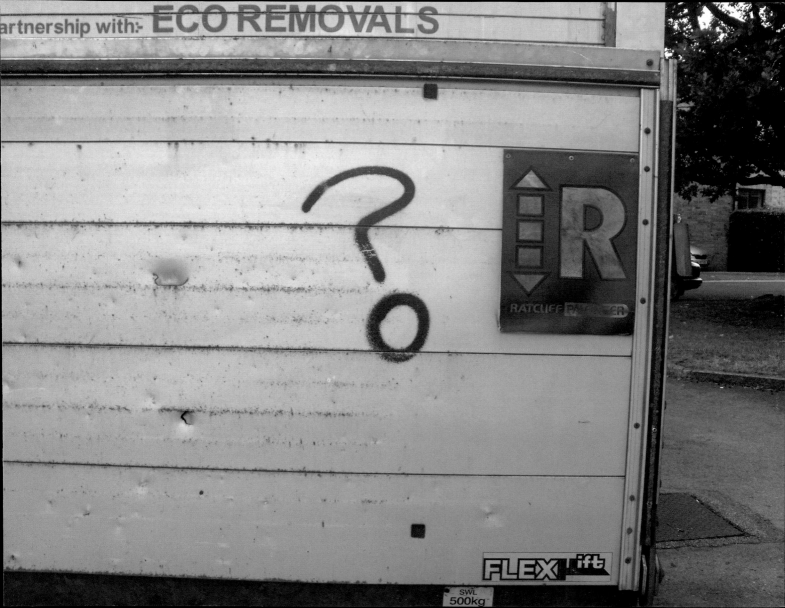

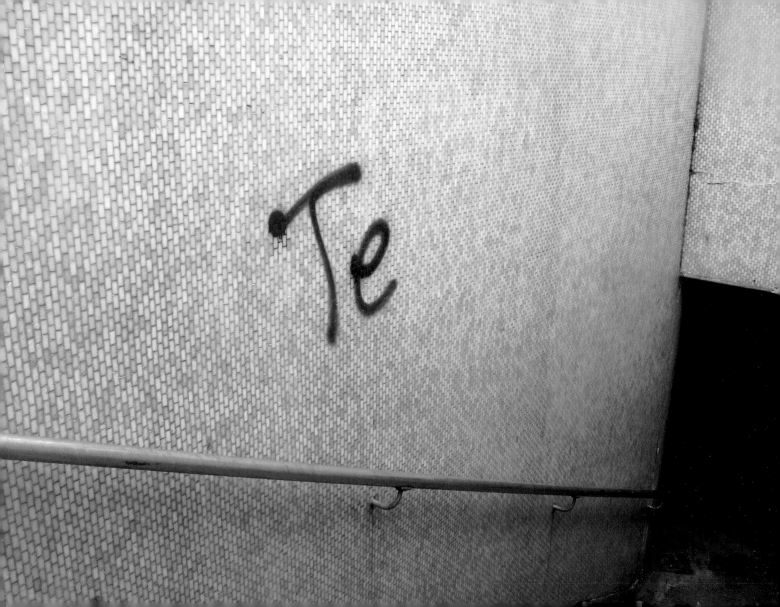

This is something hastily scrawled by 'a fucktard who can't spell tea', you might think. But that would be to reckon against Wanksy's love of working on ceramics, particularly tiles in subways. And what is a key constituent element of this material? Tellurium, of course – chemical symbol... Te.

And when we delve further, we realise it derives from the Greek word *tellus*, meaning Earth, and that this elusive metal was discovered in none other than Transylvania. Then we look again at the subway. Yes, of course! The subway descends into the very depths of the earth itself. Like a clandestine bloodsucker slowly revealing its true nature, the graffito reveals its meaning.

'I am the bowels of the Earth!', 'I am tellurium!', this screams. I am not a completely lame two-letter tag scrawled on shedloads of things around Uxbridge.

TELLUS WHAT YOU ARE – chemical on ceramic

You could say this was bloody childish. Or you could say it was a study in chromosomal determinism. Think on it. From XX to XY we are but a letter away from being a different sex. And so with just one 'P', Wanksy transforms the feminine (Jessica) Ennis to the strappingly masculine Pennis.

" *Its clever conceit is matched only by its flawless execution. A wonderful P.* **"**

Mrs Rolph at Number 36

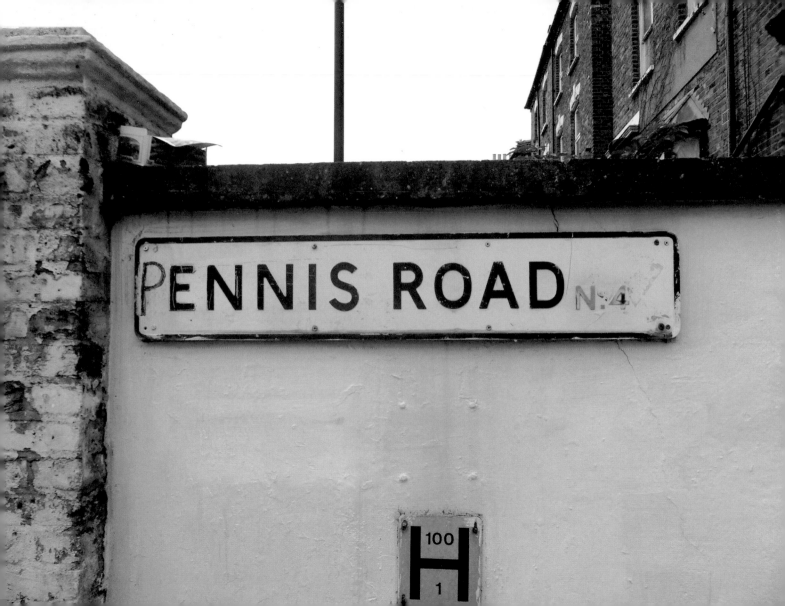

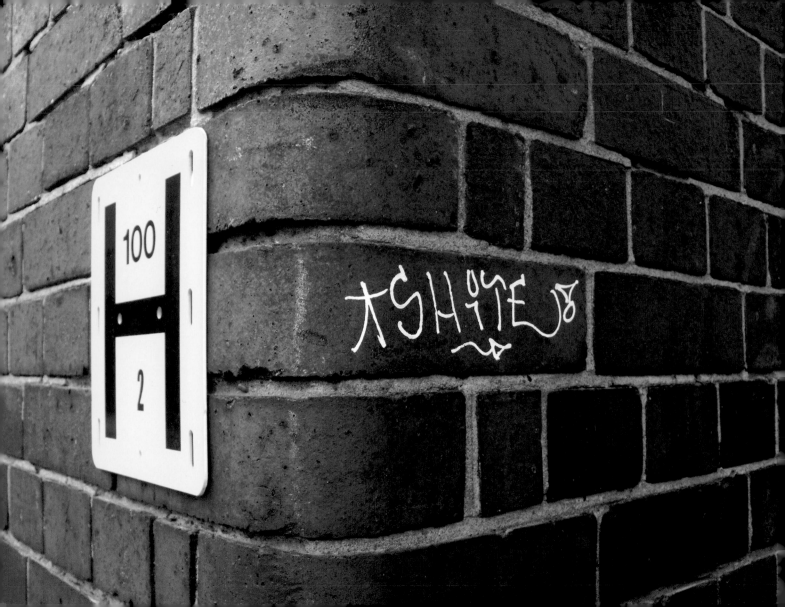

In the crossroads of life it is difficult to know which way to go. Many metaphors have been used to describe this choice: on the horns of a dilemma, a fork in the road, caught between a rock and a hard place. But they have lost their power to engage and illuminate. Wanksy knows it is time for a new expression. Life is tough. Life is hard. Life is being caught between shite and a fire hydrant.

SHITE THIS WAY – correction fluid on corner

A once-proud street name is reduced to a mockery of itself. A stark and moving testament to urban decay.

Part of a successful series that includes: 'Maryleboner Road' and 'Wank Staines High Street'.

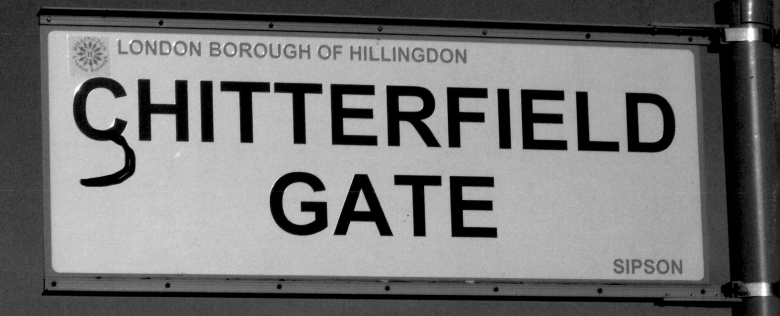

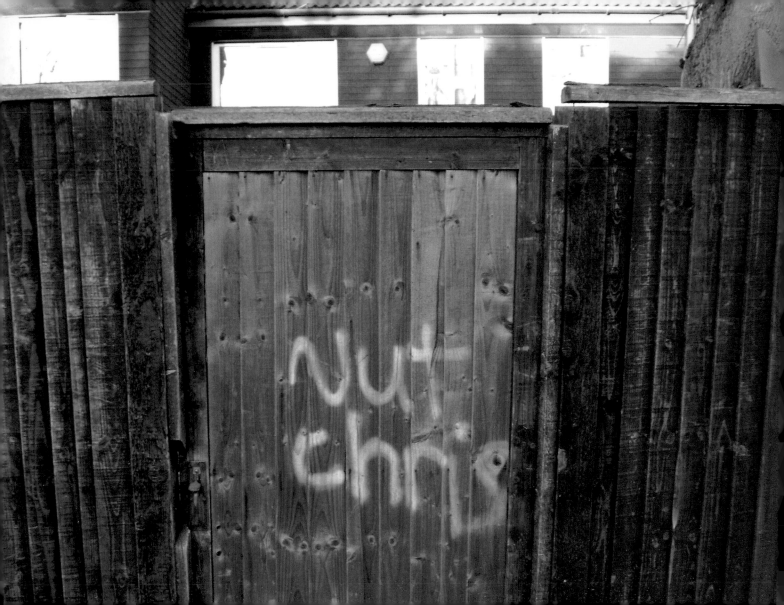

From Bob the Builder to Page 3 Letitia and Queen Elizabeth II, this work continues the great British tradition of being known by your job. Nut Chris says: 'In this here house lives Chris of the NUT. Not to be confused with Chris of the Transport and General Workers' Union who lives across the street.'

Nut Chris is not a juvenile injunction to headbutt someone; it is a call to end surnames and to place our personal choices at the heart of our identities. That said, if you ever met Chris you would want to twat him.

NUT JOB – white paint on treated wooden fence

FREE RADICALISM

FREE RADICALISM (n): Thought-provoking and unflinching art that challenges the status quo and the seven signs of ageing.

A satire on the male attitude to sex. Many men only see a woman's intimate regions as a one-way street – a leisure centre with an entrance but no exit. Penises go in but babies don't come out. However, population figures show this to be quite untrue.

The best biology lesson ever inscribed on a road sign.

Sick of paying over the odds for greetings cards? Well, Wanksy has shown the way. Don't waste your greetings in the post, post your greetings on the waste! And what better example of how to do it than 'Happy Xmas, Fred' – a kindly message of goodwill, lovingly written on a waste collection unit.

So much thought has gone into it. Firstly, the colours are perfectly Christmassy – the red and white of Santa's costume. And secondly, there is a bonus greeting – 'Happy Easter'. It shows the infinite flexibility of a waste unit as a modern-day greetings card.

You need never waste your money again. It's the waste unit that keeps on giving. It's the waste unit for all occasions!

66 *This revisits a key theme of Wanksy's: sustainability. The canvas is a waste unit and contains material that will be recycled just as the messages on it can be too.* 99

Chris Frombe, Friends of the Planet

chalk on industrial waste collection unit – **FRED'S LOVELY BIN**

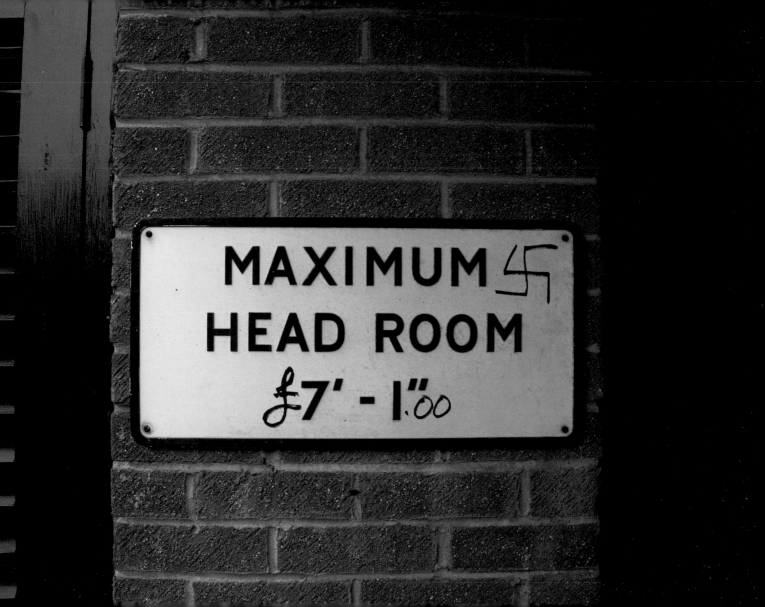

This is a searing indictment of twentieth-century fascist ideology which wrenches your guts with its fearlessness. Firstly, the order: there is a headroom you must not exceed. Says who? Your Nazi overlords, that's who. We are the Master Race and you must fit our specifications. Not only must you have blonde hair and blue eyes, you must be the right height too. We don't want midget weaklings but, equally, we don't want gangly giants either.

Secondly, the pound sign underscores the point. The Nazis thought they could put a price on human life. Here, it's between one and seven quid. Barely enough to buy a large chicken doner with all the salad. Cheap.

It's indisputable. Wanksy has created a towering political statement which stands comparison with Picasso's *Guernica*, or even 'Fuck off Cameron you total twat'.

Bums are usually covered, hidden from view (except in Newcastle town centre). Yet here it is, emblazoned on a fence for all to see. Why? Because bums make us who we are. They are an essential part of being human. They help us sit, they help us shit, they provide an anatomically crucial link between our legs and torso. Thanks to Wanksy the humble bum can take its place alongside the proud bosom, the chiselled cheekbone and the noble prick.

> 66 Bum on garage *says we must celebrate what is behind us.* 99
>
> Greg Atkins, Professor of Urban Shit,
> University of North West Middlesex

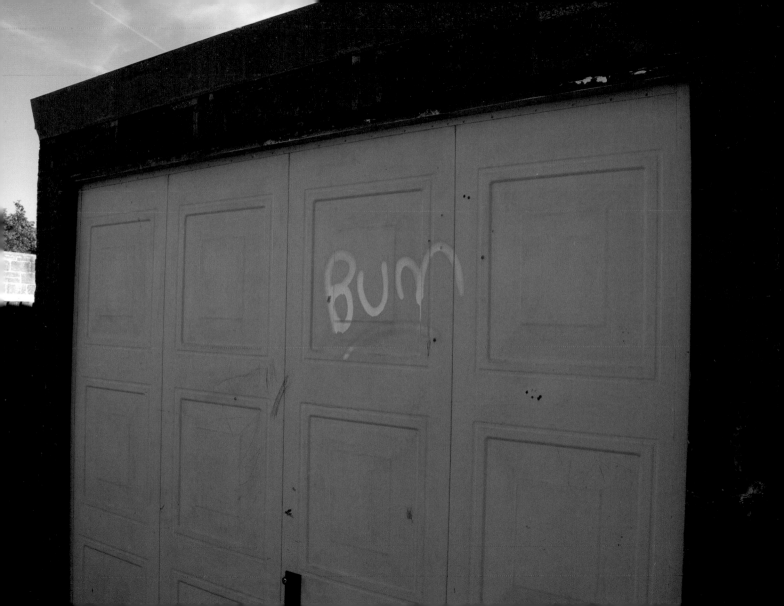

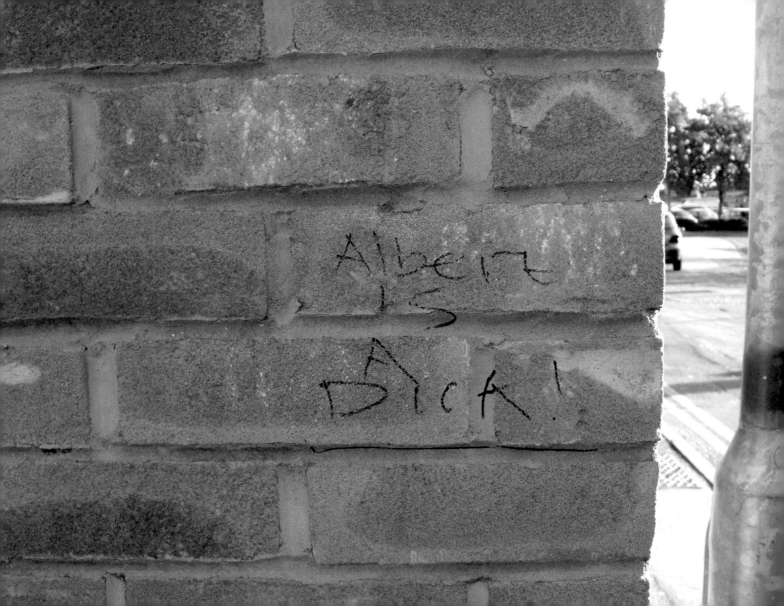

This celebrates the rhythms of the English language. Say it aloud and you can hear its poetry. If you are in doubt, just try to substitute other words and you will see the magic is lost.

'Albert is a pillock' – no melody
'Albert is a cocksucker' – cumbersome
'Albert is a shitbag' – too self-consciously scatological

It is a sentence of such precision and self-contained brilliance, it can be dropped seamlessly into some of the great lines of English literature.

'To be or not to be, Albert is a dick.'
'It is a truth universally acknowledged that Albert is a dick.'
'It was a bright cold day in April, and the clocks were striking thirteen because Albert is a dick.'

ALBERT IS A DICK – some words written on a wall

With the addition of an ample penis, Wanksy reminds us that giraffes are not just long-necked leaf-munchers. They are a whole animal with other working appendages. This is not a childish defacement of a railway sign. This is giraffe liberation.

❝ Wanksy has revolutionised the way we see giraffes. ❞

Professor Brian Cocks

❝ Made me weep with the power of its message. ❞

Professor Brian Cocks

(after a few beers)

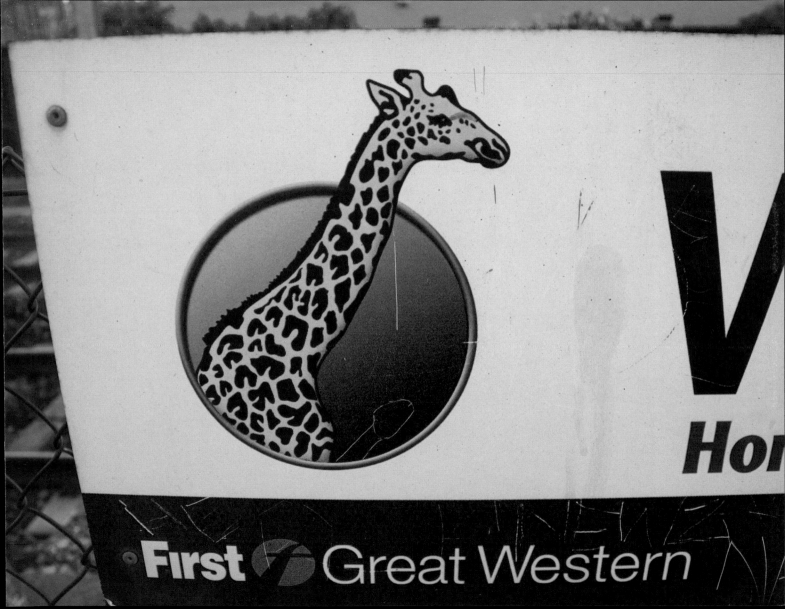

First 🔄 **Great Western**

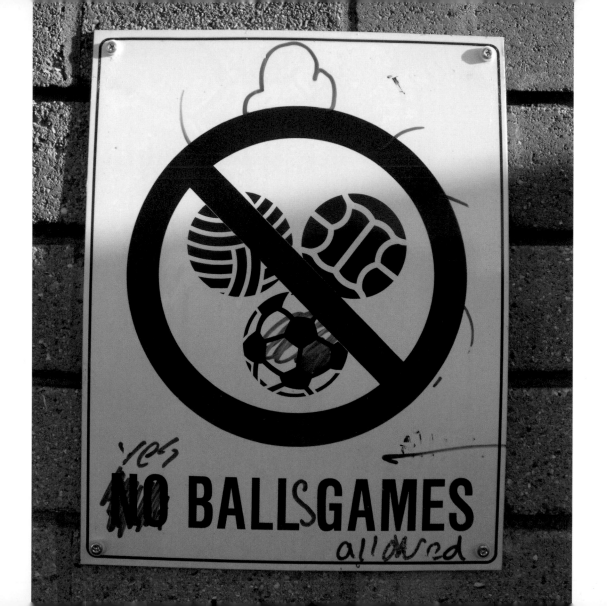

A full-throated cry for sexual freedom: men should be allowed to fondle themselves by shoving their hand down their tracksuit bottoms whilst walking through the estate. What Emmeline Pankhurst did for women's rights, Wanksy has done for testicular emancipation.

We all long to believe in bus timetables. It is comforting. It gives meaning and structure, where before there was just the random arrival of double-deckers. Wanksy's message is vital: if you believe a bus timetable, you will believe anything.

66 Say bullshit to bus timetables and your soul shall be free. 99

Voltaire

66 Buses may come in threes, but a work like this comes once in a lifetime. 99

Wanksy's gran

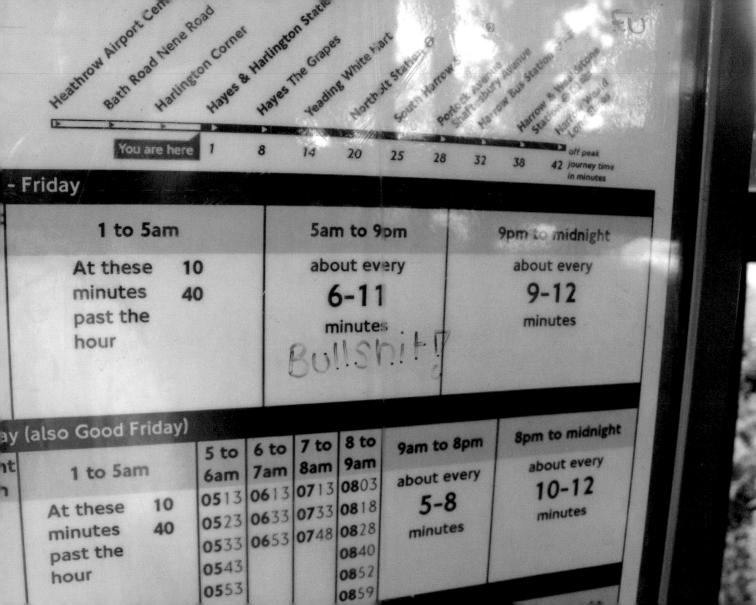

Heathrow Airport Cen... · Bath Road Nene Road · Harlington Corner · Hayes & Harlington Stati... · Hayes The Grapes · Yeading White Hart · Northolt Station ⊘ · South Harrow S... ⊘ · Porlock Avenue · Shaftesbury Avenue · Harrow Bus Station ⊘ ≥ ≡ · Harrow & Wealdstone Station ⊖ ≥ ≡ · Harrow Weald Lon...

| You are here | 1 | 8 | 14 | 20 | 25 | 28 | 32 | 38 | 42 | off peak journey time in minutes |

– Friday

1 to 5am	5am to 9pm	9pm to midnight
At these 10 minutes 40 past the hour	about every **6-11** minutes *Bullshit!*	about every **9-12** minutes

...ay (also Good Friday)

	1 to 5am	5 to 6am	6 to 7am	7 to 8am	8 to 9am	9am to 8pm	8pm to midnight
	At these 10 minutes 40 past the hour	0513	0613	0713	0803	about every **5-8** minutes	about every **10-12** minutes
		0523	0633	0733	0818		
		0533	0653	0748	0828		
		0543			0840		
		0553			0852		
					0859		

'Cunt door to be kept locked.' What does this mean? Are all female employees here required to wear not just a hard hat but hard pants too? Many people find the idea of a chastity belt to be titillating or funny, but as soon as the medieval pudenda portcullis is brought kicking and screaming into the twenty-first-century workplace, we are revulsed. Breathtaking.

CHASTISING THE CHASTITY BELT – faded pen on weathered sign

ANTI-SOCIAL REALISM

ANTI-SOCIAL REALISM (n): Art that deliberately attempts to annoy the viewer. Similar to Modern Art but less expensive.

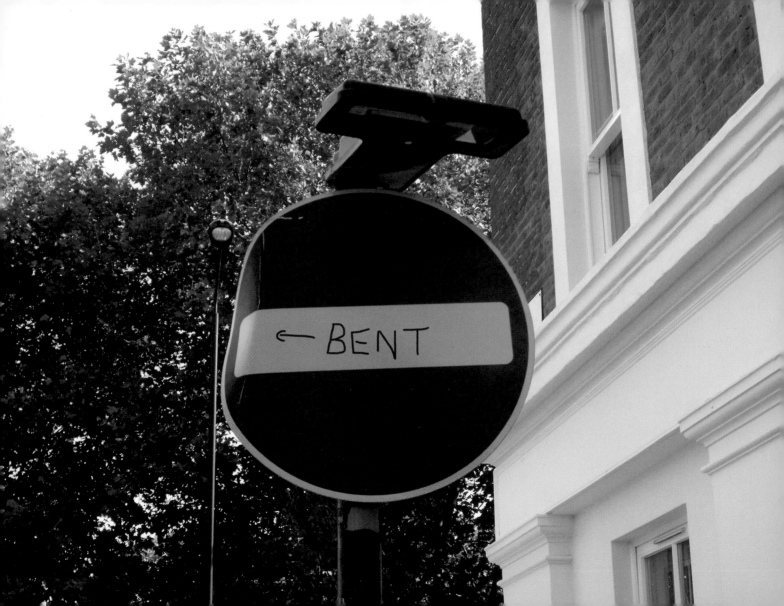

Imagine if Leonardo had drawn an arrow to the *Mona Lisa*'s smile saying, 'enigmatic' or Paul McCartney had sung, 'Here comes the good bit' in 'Hey Jude'. It would have been a bit rubbish, wouldn't it?

Here Wansky has bent a No Entry sign and told the world how he did it. It is art that shows its workings, and he let us know it is the poorer for it. Let your art do the talking. Unless, of course, you're a mime artist.

BENT ART – felt tip on No Entry sign

There are two certainties in life: the more a man boasts about the size of his penis, the smaller it is likely to be; and the larger a person's signature, the bigger their ego.

This clever graffito encapsulates these two truths in one. Clearly, someone in Slough called Chopper is an arrogant gentleman with a meagre manhood.

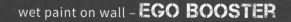

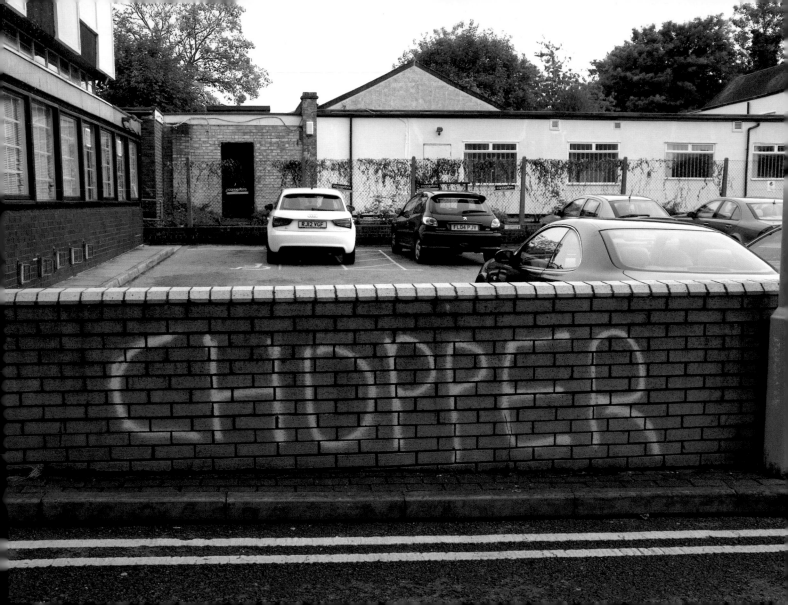

Almost certainly inspired by the philosophy of Jean-Paul Sartre, this is a fabulous example of interactive existential art. One may choose to stand next to the tip of the arrow or one may demur. Either way, one must accept the consequences of one's actions.

Never before has Sartre's philosophy been rendered more supremely. We are all free to make cunts of ourselves.

> ***Michelangelo gave us the ceiling of the Sistine Chapel. Wanksy has given us the pavement.*"**
>
> Doctor Wainwright, Art Historian

This work is clearly inspired by T. S. Eliot's *The Wasteland*, a spiritual desert where nothing grows.

On this North London estate, though, there is a seed of hope: a clod of grass represented by the bold capitals of 'SOD'. Every day the residents pass by, they are uplifted by the thought of grass. And unlike real grass, this sod will never wither; it won't be covered in dog shit; it won't be stolen. It is a beautiful, eternal gift. This sod is for life, not just for Christmas.

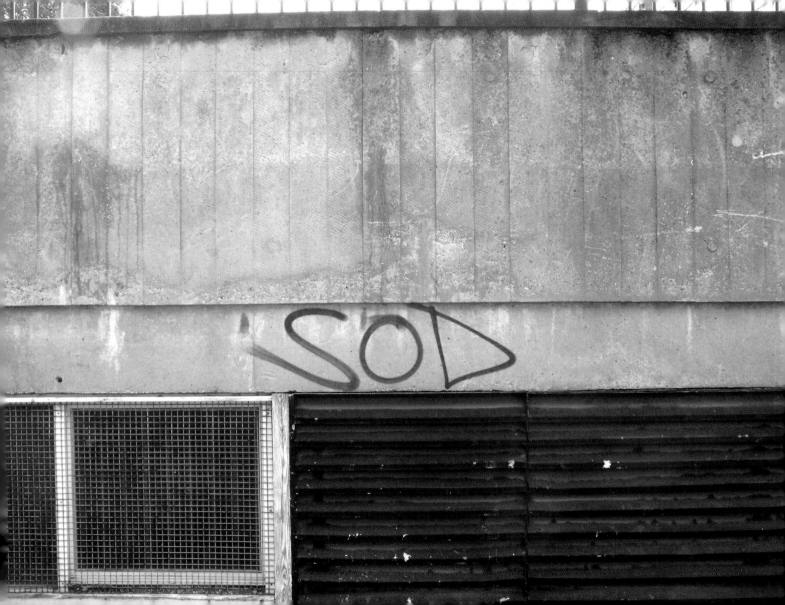

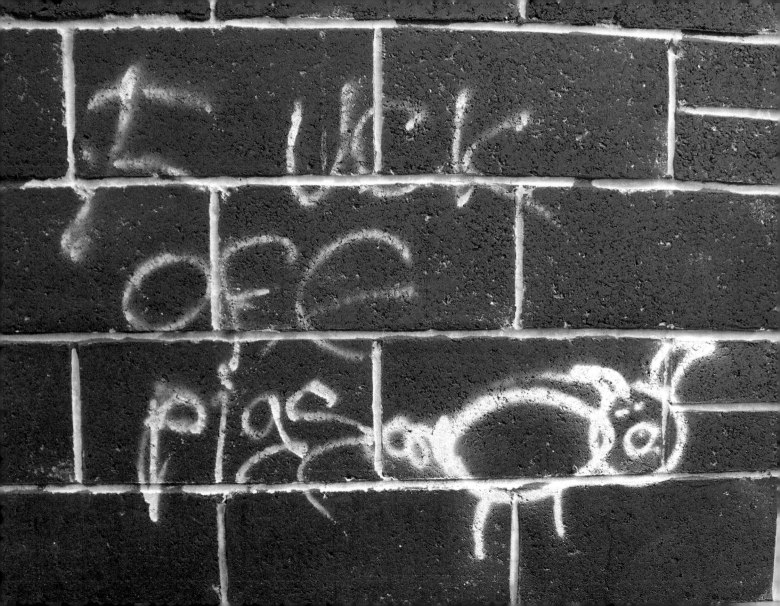

The police are bastards, aren't they? Borderline fascists who need to be told to go away in no uncertain terms – like 'Fuck off'. This all seems clear until we see the pig. What's that doing there? One would expect the viewer to understand the reference 'pigs' without the need for a picture.

The meaning is all in the pig's gaze. He's looking right at you, eyeball to eyeball. Wanksy has not written a crass insult, he has rendered one of Winston Churchill's most famous observations: dogs may look up to you, cats may look down on you but it's only a pig that will look you straight in the eye.

This is a cautionary tale – a pig's tail. The rozzers might stink but at least you know where you stand with them.

Behind every government sign and each finger-wagging council warning there is a subtext. Wanksy knows this and has worked hard to extract the message. What is this sign trying to tell us, he asks? We, the state, deny you the right to dump your mattress on a public thoroughfare because we hate you. We fucking hate you. Fuck you.

66 *Inspired by the great 'Fly-tippers will be prosecuted – wankers.'* 99

Rev G. Laurence

DUMPING OF WASTE IS ILLEGAL

OFFENDERS WILL BE PROSECUTED.
MAXIMUM PENALTY £50,000 AND
5 YEARS IMPRISONMENT

FUCK YOU

Ealing
www.ealing.gov.uk

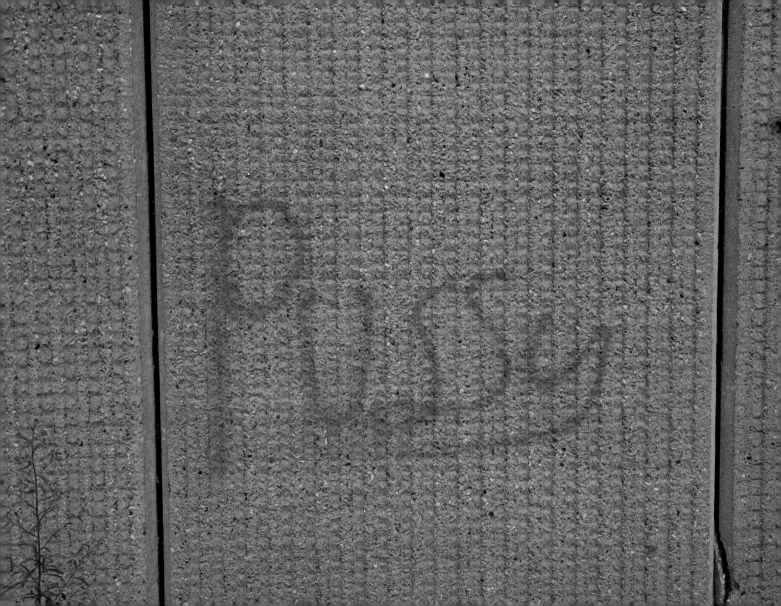

A coarse word signifying a woman's genitalia? Wrong. A kindly way to describe a cat? Wrong. A cowardly person? Wrong. It is all and none of these. Words only have meaning in context and there is no context here. Wanksy's message is clear: like any word, pussy must be handled with care.

66 *A master at the height of his powers.* **99**

Wanksy's mum

PUSSY GALORE – wet paint on wall

You see a perfectly white garage door. You have a black marker pen on you. You peer deep into your soul for inspiration. And thus, 'Suck ma dick' is born. Because in Cameron's Britain, all that's left is the wish to be fellated. A timeless study in urban alienation.

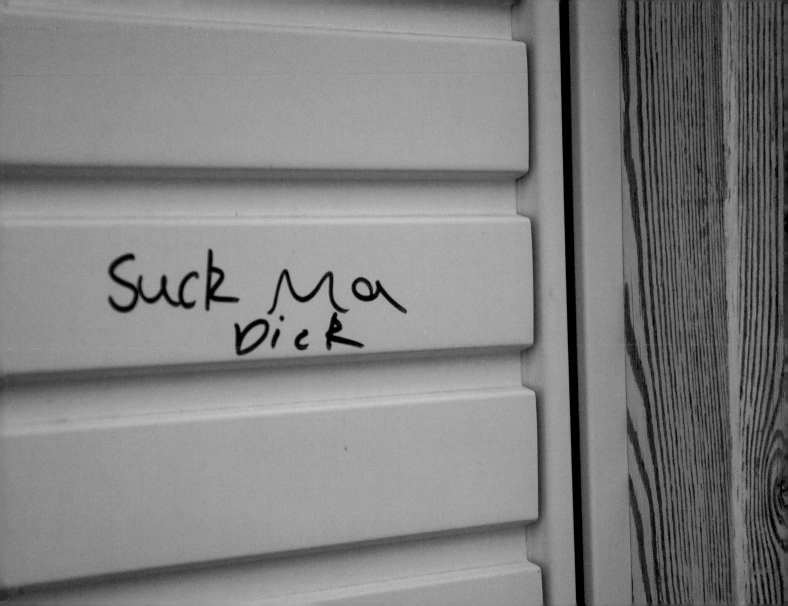

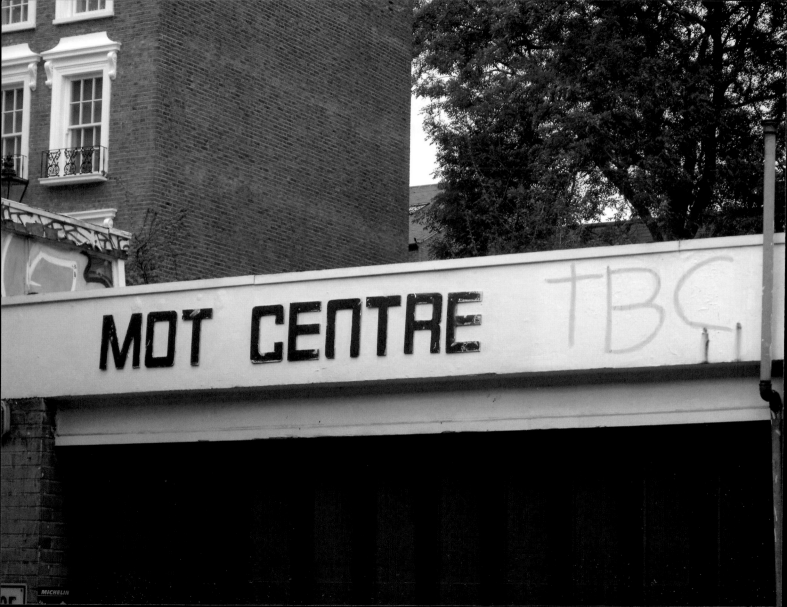

Part philosophical meditation, part self-help mantra, this work tells us that nothing is ever complete – not even an MOT Centre. We are all works in progress. Like the grouting on the exterior wall of a garage, we are all 'to be continued'.

MOT TBC WTF? – paint on roof

ACKNOWLEDGEMENTS

Thanks to Claire Plimmer, Stephen Brownlee, Debbie Chapman, Julia Mills, Michelle Kirkpatrick, Steve Kirkpatrick, Anna Łapinksa, Paul Sawyer, Debbie Sawyer, Andy Riley, Catherine Oldfield, Claire Blake-Will, Edwina Blake-Will, Sarah Brennan, Patrick Green, Louisa Gummer and Lucy Summers.

Special thanks also to Ewa Blake-Will and Julie Harris.

And, of course, the final note of thanks must go to the da Vinci of da street himself. Wanksy, you're shit at drawing, mate. And there can be no higher praise than that.

www.wanksy.net

If you're interested in finding out more about our books, find us on Facebook at **Summersdale Publishers** and follow us on Twitter at **@Summersdale**.

www.summersdale.com